EX LIBRIS

GEORGE HARRISON

George Harrison
Be Here *Now*

George Harrison
Be Here *Now*

∞

PHOTOGRAPHY BY BARRY FEINSTEIN
WITH CHRIS MURRAY

RIZZOLI
NEW YORK

New York Paris London Milan

FOR OLIVIA & JUDITH

Contents

—•• ——

George Harrison's Spirit Pal
Donovan speaks…

BEING THERE THEN

In the photo
see George playing me his new song during his 1972 recording sessions
for *Living in the Material World*.

—

In 1968 I had become his songwriting
"mentor" back in India when I taught him my descending
chord structures for his two classic songs "While My Guitar Gently
Weeps" and "Something."

—

Two years later, in 1970, with his first solo masterpiece, *All
Things Must Pass*, George simply blew away
his two fellow Beatle songwriters; and then in 1972 recorded
his new masterwork. My wife
Linda and I had invited George and Pattie to Castlemartin in Ireland for
a weekend party where this photo was taken.

—

After his time in India, George's songwriting skills had blossomed
and like the good gardener he had become, he presented
his new musical blooms to another stunned music world.

BEING THERE WHEN

George and I met in May 1965 in Dylan's suite at The Savoy Hotel;
John, Paul, Ringo, Bobbie, George and I, sitting alone together,
we six about to change popular music forever.

—

George and I shared a passion for Vedic wisdom and sitar.
I would use an open tuning on my acoustic guitar and play "Raga
Style" with Shawn Phillips, my Texan folksinger duet buddy.
Shawn and I got a sitar same time George did.

George invited us to his place, to see what East-West
sitar fusion we were developing,
Shawn showing George how he would play my melodic lines on
the low sitar string.
Soon George did the same for John's "Norwegian Wood," on
the high sitar strings.
Later, Brian Jones would play sitar on "Paint It Black."

—

Yet it was more than the sound of the sitar that George and I were
interested in; we both knew we would return meditation to the West,
through our songs, to expand the consciousness of an insane world.

—

The photographs you see in this book are taken by the great American
photographer Barry Feinstein, many never before seen from
the three George Harrison albums that Barry's camera chronicles.
George had insisted on Barry.
Back in the mid-sixties Barry had also photographed both Dylan
and me; Barry became a dear friend.

—

We all know the famous Feinstein photo from the cover of *All
Things Must Pass*, George in his "Wellies" with his gnome
friends on George's estate Friar Park, Henley.

—

Let me share here a visit Linda and I made to Friar Park
later in the seventies, a vignette of the private world of George.

—

Linda chats with Pattie in the kitchen…I walk with George into his garden…
this Green Thumb chum of mine…his smiling is a sign…he jokes
when I visit him…"it's always good to see you, Don, you never ask any
questions."
We rest beneath a tree…the leaves are bronze…"has it a name," I ask
…he says "It's called a Copper Beech," He has become
a master gardener.

—

We stand and slowly walk through exotic alpine ground-plants and bushes
…soon we reach the Mini-Matterhorn
…the eccentric Victorian creator of the estate, Sir Frank Crisp,
had George's sense of humor.
We re-join Linda and Pattie for tea.
As we make ready to return to the material world…
and silently knowing our shared angst…George looks into my eyes…
he says "The illusion is very strong, Don"…I say, "We transcend it."
Linda and I get in our car with a fond wave to our dear friends,
late afternoon sun blazing through the magnificent trees of Friar Park.

—

Now: Enjoy a rare selection of the unknown Barry Feinstein photographs,
this long-awaited visual expression of the three George Harrison
masterworks, *All Things Must Pass*,
The Concert for Bangla Desh, and *Living in
the Material World*.

—

And yes— all "things" do pass, except: the one true path in
George's songs. The ever-present wisdom path which leads to
the awakening of love…asleep within us all.

JAI GURU DEV
• •
DONOVAN

12

Awaiting On You All

*"The true artist helps the world
by revealing mystic truths."*
BRUCE NAUMAN

IT WAS GEORGE HARRISON who was the first Beatle to sing a song in America. That song was "Roll Over Beethoven," and it was a superb choice for their first concert in the United States which was in Washington, DC, February 11, 1964. Chuck Berry, who was born in St. Louis, wrote that song and is considered by many to be America's greatest rock 'n' roll songwriter. He was indeed an essential influence on The Beatles, and it was a tribute right off the bat to the American rock 'n' roll that inspired The Beatles. It was an auspicious start. Harrison tore it up that evening with a brilliant performance on guitar and vocals that drove the crowd crazy and epitomized the excitement and talent of The Beatles at that time.

George Harrison was first with a lot of things. His recording *Wonderwall Music,* in 1968, the soundtrack for the film *Wonderwall,* was the first album ever released on The Beatles' label, Apple Records. He was the first Beatle to meet an American president. Washington, DC, had been a stop on the remarkable *Harrison Family and Friends* tour. In December 1974, George was with his brother Harry, Indian classic music maestro Ravi Shankar, and keyboard player and singer extraordinaire Billy Preston, when they were welcomed by President Ford and his son Jack to the White House. George's great sense of humor and clever words made the moment that day in the Oval Office.

There were many other "firsts" for George Harrison; perhaps the most extraordinary thing he did was writing, composing, and recording the first solo album by a Beatle, *All Things Must Pass,* in 1970. That album remains the best-selling album by a Beatle to this day and demonstrates the musical genius of George Harrison. *All Things Must Pass* has sold well over six million copies.

Harrison followed up his landmark recording of *All Things Must Pass* with *The Concert for Bangla Desh.* The album from that concert won a Grammy award for Album of the Year. Harrison organized and produced two shows on August 1, 1971, at Madison Square Garden, which were the first of their kind: a rock 'n' roll all-star review organized as benefit concerts. Those historic performances and the subsequent album set the stage for concerts like No Nukes, Live Aid, and all the other benefit concerts musical artists would come to support in the future.

Following *The Concert for Bangla Desh,* in 1973 George Harrison released *Living in the Material World,* another masterwork that was certified gold only two days after its release. That remarkable recording also became the number one album on the charts in the United States, as well as number one in Canada and Australia. The single "Give Me Love (Give Me Peace on Earth)" was an international hit, and *Rolling Stone* magazine's Steven Holden wrote that the album was "miraculous in its radiance."[1]

OPPOSITE: *George Harrison enjoying* Illuminations from the Bhagavad-Gītā, *Friar Park, 1981. Photo by Chris Murray*

LEFT: *Billy Preston, George Harrison, President Gerald Ford, Jack Ford, and Ravi Shankar at the White House, December 1974. Photo by David Kennerly*

CENTER: *Album cover,* All Things Must Pass. *Cover photo by Barry Feinstein*

RIGHT: *Album cover,* Living in the Material World

OPPOSITE: *George Harrison's letter to Barry Feinstein and Tom Wilkes with suggestions regarding the* All Things Must Pass *album. Courtesy Barry Feinstein Archive*

These three recordings of Harrison's, from 1970 to 1973, form a truly amazing "Triple Crown" of musical creativity and established him as a solo artist to be reckoned with. It was quite an achievement, with much more to come.

Photographer Barry Feinstein was with George Harrison on his great endeavor; Harrison asked him to take photographs for these three albums. Feinstein's portrait of George Harrison on the cover of *All Things Must Pass* is one of the most memorable images to adorn the cover of an album. A large color fold-out poster of Harrison by Feinstein was also inside the box set for *All Things Must Pass*. This book publishes outtakes for that cover session, along with other photographs from that day of Harrison in the caves on his estate, Friar Park, walking on the grounds with his then-wife Pattie, and other rare images from a day in the life of George Harrison.

Feinstein was later asked by Harrison to be his exclusive photographer for *The Concert for Bangla Desh*. When the recording of the concerts was released as a triple live album in December 1971, it contained a sixty-four-page booklet of Barry Feinstein's photographs. Included in this book are unpublished images from that lineup of extraordinary musical artists, including Ravi Shankar, Ali Akbar Khan, Bob Dylan, Leon Russell, Ringo Starr, Billy Preston, Eric Clapton, Badfinger, Jim Horn, and more.

Harrison also asked Feinstein to take pictures of the photo session for *Living in the Material World* in Los Angeles in 1973. Harrison had built an elaborate and somewhat surreal set for that shoot, which featured a large table outdoors—a bit of a Mad Hatter's tea party. The characters in George's scenario were none other than the musicians from the album, with George presiding. Images from that shoot in Los Angeles include photographs of Harrison with Ringo Starr, Klaus Voormann, Jim Keltner, Jim Horn, and Nicky Hopkins.

"Well I obviously thought a great deal of Barry's pictures.
I think Barry was an incredibly great photographer
as I still do to this present day."
BOB DYLAN

Barry Feinstein was born February 4, 1931. He grew up in Philadelphia, and after three years playing varsity football at South Philadelphia High School, he attended the University of Miami on a football scholarship. He began his career as an assistant sports cameraman in the 1950s. In 1957, Feinstein was employed by Harry Cohn at Columbia Pictures and worked on more than two dozen films as a production assistant. He was on the set for movies with Spencer Tracy, Kim Novak, Jack Lemmon, Danny Kaye, and Frank

ABOVE: *Album cover,* The Times They Are A-Changin'. *Cover photo by Barry Feinstein*

Sinatra, among others. Not long after his days as a PA, he established himself as a freelance photographer and photographed Elizabeth Taylor, Steve McQueen, Salvador Dalí, Marilyn Monroe, the Black Panthers, the March on Washington in 1963, and more. His work was published in *Life, Esquire, Newsweek,* and *Time* magazines, and numerous other publications. Feinstein was the exclusive photographer on two of Bob Dylan's European tours between 1964 and 1966, and took some of the finest photographs ever seen of Bob Dylan. It is Feinstein's photo of Dylan, taken in 1963, that is featured on the cover of his remarkable album *The Times They Are A-Changin'.*

In 1969, Feinstein and his friend Tom Wilkes started Camouflage Productions, specializing in photographing, designing, and packaging album covers, books, logos, billboards, and more. It was during this time that Feinstein started working with George Harrison.

Barry Feinstein was a good man to be around. He could tell a great story, was trustworthy, dependable, and a straight shooter. That's why people like Marlon Brando, Janis Joplin, and Bob Dylan enjoyed working with Barry; he was that kind of guy.

I came to know Barry Feinstein when I contacted him to host the first exhibition of his photographs in November 2002 at Govinda Gallery. I was quite taken by his photo of George Harrison

on the cover of *All Things Must Pass* and I sought Barry out. Since Annie Leibovitz's first exhibition at Govinda Gallery in 1984, I was systematically finding, acquiring, exhibiting, and selling to collectors significant photographs documenting musical artists. We championed the genre of music photography. I considered Feinstein's image for *All Things Must Pass* to be one of the great photographs of that genre. It was an intriguing and compelling image. The cover of George's first solo album had a massive impact. The Beatles had split up and there was a great deal of speculation about their future. George busted out with a record so powerful and profound that it blew everyone away, and Barry was there to make the perfect photo for the cover.

Find me where ye echo lays
Lose ye bodies in the maze
See the Lord and all the mouths he feeds
Let it roll among the weeds
Let it roll
"BALLAD OF SIR FRANKIE CRISP
(LET IT ROLL)"

It is hard to imagine the impact Harrison's *All Things Must Pass* had when it was released. The Beatles' breakup was unsettling; they had established themselves as the greatest band of all time, with each of its members forging significant indi-

vidual personas within the group. Their split was a shock to many fans and admirers. The Vietnam War was raging, and the assassinations of Martin Luther King, Malcolm X, and the Kennedy brothers still reverberated; it was a time of change, and people were anxious about the future. The Beatles had become a source of musical magic that inspired millions during those turbulent times, and now they had broken up as a band. Harrison's epic album was, in a way, a brave new world. The title, *All Things Must Pass*—a comment on the nature of the material world—was at the same time a nod to each of the Beatles going their own way. Best friends since their youth, they were now grown up and were on their own. Feinstein's photograph on the album's cover seemed to capture and complement the mood of the moment.

The songs on *All Things Must Pass* revealed a deeply thoughtful and philosophical Harrison, qualities he had expressed while he was with The Beatles in songs he wrote such as "Within You Without You," "It's All Too Much," and "I Me Mine." But with the album *All Things Must Pass*, his realizations and conviction expanded and were given a deeply personal showcase.

The title song, "All Things Must Pass," was remarkable. Harrison was inspired by a number of ancient books of the East. Among them was the Chinese text *Tao Te Ching*, also known as *The Way of Life*, by Lao Tzu. There are many transla-

tions of that text, and one of them is called *Psychedelic Prayers* by Timothy Leary, published in 1966. Harrison had participated in psychedelic sessions and was well aware of Leary's writings. John Lennon's song "Tomorrow Never Knows" from the Beatles' *Revolver* album in 1966 had been based on Leary's revision of *The Tibetan Book of the Dead*, retitled *The Psychedelic Experience*. Harrison's lyrics for the song "All Things Must Pass" were inspired in part by Leary's translation of Chapter I, Verse V from *The Way of Life* titled "All Things Pass."

While Harrison's revelations from psychedelics opened the doors of perception for him, he went on to practice mediation, chanting, and prayer without the aid of psychedelics. His spiritual quest was steady and sincere. *All Things Must Pass* confirmed and acknowledged the truths he was discovering and inspired millions of people who relished his music.

Harrison had famously gone to India in 1968 with his bandmates and Donovan to learn transcendental meditation at Maharisi Mahesh Yogi's ashram in Rishikesh. He had also been greatly impressed by his mentor Ravi Shankar, who emphasized the spiritual dimension music can have. Ravi told his young friend that, "Music has the power to lead you towards God."[2] Harrison was introduced by Ravi Shankar to the book *Autobiography of a Yogi* by Paramahansa Yogananda, which made a significant impression on him.

LEFT: Psychedelic Prayers *(University Books) by Timothy Leary*

CENTER: Rādhā and Kṛṣṇa in Their Eternal Abode, Goloka Vṛndāvana. *Painting by Parīkṣit dāsa*

RIGHT: Autobiography of a Yogi *(Self-Realization Fellowship) by Paramahansa Yogananda*

It was when he met the distinguished scholar and guru A.C. Bhaktivedanta Swami, who promulgated the chanting of the Hare Kṛṣṇa mantra, that Harrison became a devotee of Kṛṣṇa and took up chanting and Bhakti Yoga. Swami Bhaktivedanta was part of a spiritual lineage that traced back to Śrī Caitanya Mahāprabu, a fifteenth-century ecstatic saint known as the Golden Avatar. Śrī Caitanya celebrated the Sankirtan movement in India—congregational singing and dancing to sacred chants and music in order to develop *Kṛṣṇa-Prema*, love of Kṛṣṇa. It is no surprise that Harrison was drawn to this ecstatic form of prayer.

Harrison came to know and befriend western devotees of Swami Bhaktivedanta in London. He was so taken with the process of chanting that he produced *The Radha Kṛṣṇa Temple* album, which was released on Apple Records, featuring traditional devotional songs and mantras in Sanskrit by members of the Hare Kṛṣṇa temple in London. The single "Hare Kṛṣṇa Mantra" was a surprise hit in England during the summer of 1969.

The song "My Sweet Lord" from *All Things Must Pass* summed it up for Harrison musically and spiritually, combining gospel music with rock 'n' roll and the chanting of transcendental mantras. It was an extraordinary song that spoke of Harrison's deep emotion and his spiritual yearnings. It was tremendously uplifting to listen to "My Sweet Lord." It was powerful. The legendary Phil Spector co-produced the album, and his signature "wall of sound" resounds throughout the recording.

The triple album was nothing less than a musical tour de force packaged in a beautiful box with a poster, and while everyone played the album and listened intently, one would marvel at Feinstein's compelling portrait of Harrison on his lawn at Friar Park sitting with four garden gnomes on its cover. It was a monumental recording and a monumental image. Fifty years later, *All Things Must Pass* remains a great musical work—still resonating, still inspiring, and still grooving.

> *Although I couldn't feel the pain, I knew*
> *I had to try*
> *Now I'm asking all of you*
> *To help us save some lives*
> "BANGLA DESH"

The sustained roar that greeted George Harrison when he appeared onstage at Madison Square Garden on August 1, 1971 to a sold-out crowd for the Concert for Bangla Desh was like a wave of love enveloping him. Harrison had rarely appeared in public since The Beatles stopped touring in 1966. It was a thrilling moment. Only a few months after the release of *All Things Must Pass*, Harrison was asked by his friend Ravi Shankar if he could help in some way the refugee crisis in Bangladesh that had led to a famine and the displacement

ABOVE: *Śrī Caitanya Mahāprabu, Indian print, circa nineteenth century*

OPPOSITE, LEFT–RIGHT: *George's design idea for insert promoting* The Radha Kṛṣṇa Temple Album; *George Harrison's handwritten note to Barry Feinstein and Tom Wilkes with an idea for possible insert in* All Things Must Pass *to promote* The Radha Kṛṣṇa Temple *album*

Sept. 1, 1971

Mr. Barry Feinstein
CAMOUFLAGE PRODUCTIONS
7840 Fareholm Drive
Hollywood, California 90046

Dear Barry:

20

Thank you for all your help.

Hare Krsna

George

George Harrison

of its people. Harrison loved Ravi Shankar, and with a compassionate heart he put together an all-star band to play two concerts on the same day at Madison Square Garden to benefit the United Nations Children's Fund (UNICEF) for relief to refugee children of Bangladesh. It was a historic concert with great significance. Ravi Shankar has said, "It was really a miracle."[3] Eric Clapton spoke of how Harrison's solo album *All Things Must Pass* had dramatically attracted the attention of the music community; Clapton said *"All Things Must Pass* gave George an incredible amount of clout. He could have asked anyone to play in that concert."[4]

Harrison called for a week of rehearsals in New York City. He wanted the band to be in great form. Ringo, Jim Horn, Klaus Voormann, Jim Keltner, and Eric Clapton were there. George set about arranging the music and took control of the scene. When Dylan arrived at the rehearsal, one sensed it could be a historic event.

Harrison started the concert with an "Indian Music Section," introducing sitar maestro Ravi Shankar, the master of the sarod Ali Akbar Khan, the charismatic Alla Rakah on tablas, and Kamala Chakravarty on tambora. These musicians were masters of classical Indian music. The audience at Madison Square Garden received their performance with great respect and appreciation; there was a sense of unity between the audience and the musi-

cians on the stage, and at that point the audience became part of the show. It was an extraordinary performance of the classical Indian music tradition, and it set the mood for the evening in a sublime manner and was a portent of things to come.

Later, without an introduction, George Harrison and the band walked onstage—and what a band it was! Eric Clapton on guitar stood close to his friend George. Harrison enlisted the ultimate drum duo for the concert: his dear friends Ringo Starr and Jim Keltner. Harrison, who had played on Leon Russell's first album and knew his work with Delaney & Bonnie and Mad Dogs & Englishmen, recruited Russell to be on keyboard. Klaus Voormann, George's lifelong friend from when he was seventeen and performing in Hamburg with The Beatles, was on bass. The dynamic Billy Preston, who played on The Beatles recording of "Get Back," was also on keyboards. Jesse Ed Davis was on rhythm guitar. Accompanying the band was saxophone player Jim Horn, along with an incredible group of backup vocalists.

And then, of course, there was Bob Dylan, perhaps the emotional heart of the show. Dylan had spent the last few years living near Woodstock out of the public eye. When Harrison introduced him, the crowd rose to its feet with a thundering welcome. His presence on the stage was profound. He and George had a very close friendship, and it was wonderful to see him come

ABOVE: *Leon Russell, Bob Dylan, George Harrison, and Ringo Starr, The Concert for Bangla Desh. Photo by Barry Feinstein*

OPPOSITE: *Letter of thanks from George Harrison to Barry Feinstein with a copy of the check from Madison Square Garden Center, Inc., for the proceeds from The Concert for Bangla Desh*

ABOVE: *Photo by Barry Feinstein for the back cover of the booklet in the box set for* The Concert for Bangla Desh

out for his friend and in support of the cause. *Rolling Stone* magazine founder and editor Jann Wenner said, "I think when you got there, you really were expecting the biggest rock 'n' roll event of all time. And I think it delivered on it."[5]

Barry Feinstein was the only photographer to photograph the concert on George's behalf. "I was really invisible when I worked,"[6] Feinstein said. He was often onstage shooting from behind the performers.

Feinstein was a great friend of Bob Dylan, having been his photographer on two tours in England as well as a cross-country road trip they took together in 1964. Barry was very comfortable onstage with all of the musicians, many of whom were friends. Feinstein's photographs are a visual document of these great performances. The film Harrison had made of the concert was released several months later in March 1972. Harrison and his friends' efforts eventually raised more than twelve million dollars in support of UNICEF for relief to refugee children of Bangladesh.

*I'm grateful to anyone
That is happy or free
For giving me hope
While I'm looking to see
The light that has lighted the world*
"THE LIGHT THAT HAS LIGHTED
THE WORLD"

George Harrison's transcendent musical vision continued with his next masterwork, *Living in the Material World*. Harrison started recording a new collection of his songs in autumn 1972. He was more committed than ever to a poetic expression that boldly declared his insights and realizations as a result of his study of India's ancient Vedic texts and his regular practice of chanting sacred mantras. Pattie Boyd said of this time that "he became totally absorbed with meditation."[7]

At this point, Harrison had developed a close association with Swami Bhaktivedanta, or Śrīla Prabhupadā, as he was affectionately known by his disciples. His seriousness as a spiritual teacher and as a pure devotee of Kṛṣṇa was evident to Harrison. He was an authentic guru; he could deliver the goods. He was someone Harrison had been searching for, and a great spiritual bond developed between them.

Śrīla Prabhupadā was a scholar of Vedic literature and had translated numerous important texts from Sanskrit to English, including the *Bhagavad-Gītā As It Is*. George was so immersed in studying the Gītā, he used the painting of Kṛṣṇa and Arjuna on its cover for the lyric sheet that came with every copy of *Living in the Material World*, as well as on the vinyl label. Harrison was spreading Kṛṣṇa consciousness.

Kṛṣṇa and Śrīla Prabhupadā's inspiration is evident in the title song "Living in the Material

N.Y. Thursday.

Dear Tom, Alan + Barry.

This is the idea - but I know you can improve on it. I think the White with the Orange is very good and maybe more white or Black/White on the front of the Box would be a good Idea. (ie. Lettering + the photo.)

This is not the real label copy.
Sorry about the kid, but that's what they really look like in reality.

George.

CLOCKWISE, FROM TOP LEFT:
George Harrison's handwritten note to Barry Feinstein and Tom Wilkes about the box set cover of The Concert For Bangla Desh *album. Courtesy Barry Feinstein Archive; Medal given to participants in The Concert for Bangla Desh (front); Medal inscribed with Barry Feinstein's name (back); Album cover,* The Concert for Bangla Desh

World," as well as in "The Light That Has Lighted The World," "Give Me Love — (Give Me Peace on Earth)," and "The Lord Loves the One (That Loves the Lord)," among others. The album was all about love, something George had been singing about for a long time. His mystical yearnings had matured into spiritual realization. *Living in the Material World* went on to become his second number-one album in the United States and was a hit all over the world.

Harrison organized a photo session for *Living in the Material World* at entertainment lawyer Abe Somer's Tudor-style mansion in Los Angeles. Barry Feinstein was invited by Harrison to take pictures along with photographer Ken Marcus. A number of the musicians on the album also had cameras, as seen in Feinstein's photos from that day. Harrison had a great sense of humor; after all, he was a great friend of Peter Sellers and the comedic troupe Monty Python. Eric Idle was particularly close to George. Harrison directed a scene on the lawn of the mansion with a great feasting table, a limousine and chauffeur, a nurse, and a maid. It was a satirical take on the traditional view of success and fame—living in the material world. Feinstein's photos of the day are a rare account of the proceedings.

This book resonates with me in a very special way, as it was my good fortune to come to know George Harrison. My first book, *Illumi-* *nations from the Bhagavad-Gītā*, was published by Harper & Row in 1981. Stunningly illustrated by the artist Kim Waters, this tribute to India's most famous book of wisdom was much appreciated by George.

One day while I was in London, I received a phone call from George's book publisher, Brian Roylance of Genesis Publications in England. My gallery in Washington D.C., Govinda Gallery, was the exclusive U.S. distributor for Genesis Publications, who had published Harrison's beautiful signed limited-edition book *I Me Mine*. Roylance had given Harrison a copy of *Illuminations from the Bhagavad-Gītā* and told me that I was invited by George to come and visit him at his home, Friar Park, his Victorian-Gothic chateau and gardens near Henley-on-Thames.

It was one of the great pleasures of my life to visit George at his extraordinary home. His wife Olivia and young son Dhani were also home that day. George took me on a walk through the beautiful thirty-six acre formal gardens that he had restored on the great estate. It was wonderful seeing him tend to his garden as we walked and talked together. George loved nature and it inspired him deeply. You could see that in the way he cared for his garden. The dedication to his first book *I Me Mine* is "to gardeners everywhere."

I took some photos of George, his gardens, and his home that day. After our walk through

LEFT: Bhagavad-Gītā As It Is *(The Macmillan Company)*

CENTER: *A. C. Bhaktivedanta Swami Prabhupāda, 1975. Photo by Chris Murray*

RIGHT: Illuminations from the Bhagavad-Gītā *(New York: Harper Colophon Books, 1980) by Kim Waters and Chris Murray*

OPPOSITE: *Olivia and Dhani Harrison at their home, Friar Park, 1981. Photo by Chris Murray*

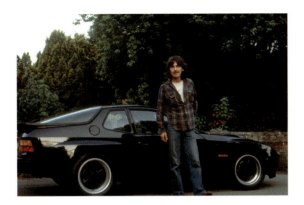

the gardens, he made us coffee in his kitchen while we looked at *Illuminations*. We had a great time together.

When it was time to leave, George walked Brian and me to our car. It was late in the afternoon, and the sun was setting behind the trees. It had been a beautiful day. George was standing by his car as we were about to get in ours. I knew George liked fine automobiles, and I took a last photo of him in front of his black Porsche. It was a great ending to a blissful day. I will always remember how kind George was to me. As Brian and I drove off, I looked back at George and we waved goodbye.

After *Living in the Material World*, George released eight studio albums, the concert album *Live in Japan*, and two albums with the Traveling Wilburys. George also collaborated on four albums with Ravi Shankar. All of these recordings are remarkable in their own way.

I continued to distribute Harrison's limited-edition books for Genesis Publications, including *Songs by George Vol. 1* and *Vol. 2* and *Live in Japan*. When George passed on, I was moved to organize the exhibition *George Harrison 1941–2001: A Photographic Tribute* at Govinda Gallery. The response to the exhibition was overwhelming. I had shown many photos of him over the years in exhibitions featuring The Beatles. This exhibition included images of George by Barry Feinstein, Linda Mc-

Cartney, Astrid Kirchherr, Harry Benson, Jurgen Vollmer, Gered Mankowitz, Robert Whitaker, Max Scheller, Baron Wolman, David Hume Kennerly, Mark Seliger, and William Coupon. I remain grateful to those photographers for helping me honor George and his legacy. As they say, a picture is worth a thousand words.

I was very fortunate that my friend Brian Roylance arranged for me to be invited to the Concert for George at the Royal Albert Hall in London on November 29, 2002, one year to the day after George's passing. It was a remarkable gathering of musical artists who had been close to George and who loved him dearly. Among them were Ravi Shankar and his daughter Anoushka, Eric Clapton, Ringo Starr, Paul McCartney, Tom Petty and the Heartbreakers, Jim Keltner, Jools Holland, Jeff Lynne, Jim Horn, Albert Lee, Ray Cooper, Billy Preston, Sam Brown, Jim Capaldi, Tom Scott, and George's beloved son Dhani Harrison. The Monty Pythons were also in attendance.

The concert was healing for everyone. Many were still grieving his passing. There was a beautiful selection of photographs of George that were projected above the stage during the concert. Ringo's remarks were simple and heartfelt: "You know, I loved George. George loved me."[8] He sang the song "Photograph," which he had co-written with George. I don't think there was a dry eye in the house. I was so grateful to be there.

ABOVE: *George Harrison with his Porsche 928, Friar Park, 1981. Photo by Chris Murray*

OPPOSITE: *George Harrison tending lilies in Friar Park, 1981. Photo by Chris Murray*

I also was fortunate to attend the induction ceremony for George into the Rock & Roll Hall of Fame at the Waldorf Astoria Ballroom on March 15, 2004. Tom Petty gave George's induction speech that evening. Tom loved George; his collaboration with him in the Traveling Wilburys was a testament to their friendship. At the conclusion of the ceremony, Prince, who had also been inducted that evening, ended the concert with "While My Guitar Gently Weeps." It is often said that Prince's performance that night was perhaps the single finest musical moment in the ceremony's history.

George was beloved. He was soulful. He was also courageous. He was an extraordinary guitar player, and a devoted ukulele player. He was charming, yet did not suffer fools gladly. He was a true bohemian. He was a great poet. He was a devotee. He was a husband and a father. He was a friend.

George Harrison and Barry Feinstein's paths were meant to come together. They were two creative individuals who complemented each other—one born in Liverpool and the other born in Philadelphia. It is fifty years since *All Things Must Pass* was released and these photos were first taken. Harrison's music and song have proved to be timeless, and Feinstein's photos still delight the eye and tell their story. Their work will always remain with us in sound and vision.

"Never was there a time when I did not exist,
nor you, nor all these kings; nor in the future shall
any of us cease to be."
BHAGAVAD-GĪTĀ, CHAPTER 2, VERSE 12

CHRIS MURRAY
Washington, DC

LEFT: *Chris Murray with Barry Feinstein at his studio in Woodstock, NY, 2009*

RIGHT: *Photo for the fold-out poster for the* All Things Must Pass *box set. Photo by Barry Feinstein*

OPPOSITE: *Barry Feinstein. Photo by George Harrison*

29

1. Holden, Stephen. "Living In The Material World." *Rolling Stone*, 19 July 1973. | 2. Shankar, Ravi. *Raga Mala: The Autobiography of Ravi Shankar.* Surrey, England: Genesis Publications, 1997. | 3. Ibid. | 4. *George Harrison: Living in the Material World* [DVD]. Directed by Martin Scorsese. United States: Grove Street Pictures, Spitfire Pictures, Sikelia Productions, 2011. | 5. *The Concert for Bangladesh Revisited with George Harrison and Friends.* [DVD] Directed by Saul Swimmer. United States: Apple Films, 2005. | 6. *Bob Dylan—World Tours 1966–1974: Through the Camera Of Barry Feinstein.* Directed by Joel Gilbert. United States: MVD Visual, 2005. [DVD]. | 7. Boyd, Pattie. *Wonderful Tonight: George Harrison, Eric Clapton, and Me.* New York: Three Rivers Press, 2007. | 8. *Concert for George* [DVD]. Directed by David Leland. United Kingdom: Ray Cooper, Olivia Harrison, Jon Kamen, Brian Roylance, 2003.

All Things *Must* Pass

42

The Concert *for* Bangla Desh

144

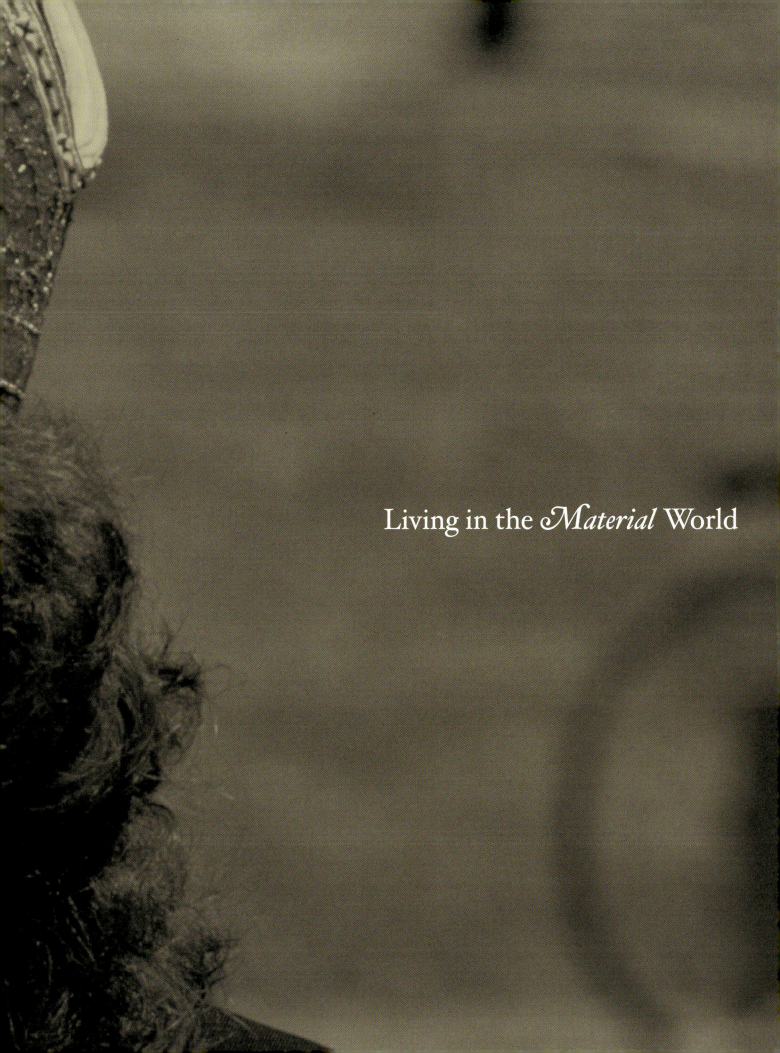

Living in the *Material* World

ACKNOWLEDGMENTS

I WANT TO THANK Charles Miers and Jessica Fuller at Rizzoli for bringing this book to publication. I am deeply grateful for all that you and the terrific team at Rizzoli do. A big shout out to John, Laura, and everyone at Opto Design for helping make this such a fine book. A heartfelt thank-you to Donovan for your words and your friendship with George. You are soul brothers. My appreciation to everyone at Govinda Gallery for assisting me with my work for this book. I want to especially acknowledge my wonderful assistant Merissa Kaczmarczyk, along with David Murray, Claire Hines, Chad Davis, and Cassidy Pregil. I would like to remember my dear friend, the brilliant publisher Brian Roylance, who first introduced me to George. A very special thank you to Kim Waters for her beautiful artistry. George loved your work. To Michael Meyer for always making me feel at home—you are amazing! To Philip Moreau and Donnie McIlvaine and for their support and enthusiasm for this project. To Kim Pappaterra in Los Angeles, and to John Hughs and Wade Hornung at Adamson Editions, who are always there for me. Thank you to Jake Jamison and Pete Mauney for helping me pull everything together on behalf of Barry. To my longtime chum Fred Gretsch, a country gentleman. Thanks to photographer Ken Marcus for his advice. To Pattie Boyd for a lovely lunch in Washington. A shout-out to David Kennerly, a great photographer and a great guy. To Damodar Das for his friendship and kindness, to Bhadaraj and Pariksit for their wonderful paintings, and to Shyamsundar Das and Mukunda Das for their love of George. And most of all, to my beautiful wife Carlotta for her love, laughter, and friendship. ~ *Chris Murray*

ABOVE: *George Harrison blowing his conch shell at his Rādhā Kṛṣṇa home shrine. Photo by Barry Feinstein*

OPPOSITE: *Chris Murray at Friar Park, 1981. Photo by George Harrison*

ALL GLORIES TO SRI KṚṢṆA

208 COPYRIGHT:

First published in the United States of America in 2020 by
Rizzoli International Publications, Inc.
300 Park Avenue South
New York, NY 10010
www.rizzoliusa.com

Copyright © 2020 Barry Feinstein Photography and
Chris Murray
Texts: Donovan; Chris Murray

Publisher: Charles Miers
Editor: Jessica Fuller
Design: Opto Design
Managing Editor: Lynn Scrabis
Production Manager: Colin Hough-Trapp

Printed in China

2020 2021 2022 2023 / 10 9 8 7 6 5 4 3 2 1

ISBN: 978-0-8478-6775-2
Library of Congress Control Number: 2020931952

Visit us online:
Facebook.com/RizzoliNewYork
Twitter: @Rizzoli_Books
Instagram.com/RizzoliBooks
Pinterest.com/RizzoliBooks
Youtube.com/user/RizzoliNY
Issuu.com/Rizzoli

Photo Credits:
Barry Feinstein: pp. 9–10, 14, 16, 21–22, 29, 207;
Govinda Gallery Archive: p. 29;
George Harrison: pp. 28, 78–79, 206;
David Kennerly: © David Kennerly p. 14;
Chris Murray: © Chris Murray pp. 12, 24–27;
© Stewart Lawrence/Donovan Discs: p. 9;
© Kim Waters: George Harrison Book Plate, p. 13.